WENLOCK PR

SHROPSHIRE

❖

Julie Pinnell

The priory at Much Wenlock is now a peaceful and beautiful ruin. A religious house was first founded on this site in around AD 680, when the Saxon king, Merwalh, of Mercia, built a monastery for men and women. Merewalh's daughter, Milburge, was its second abbess, and soon became famous for the miracles she was said to have performed. After her death she was recognised as a saint.

The monastery was replaced, shortly before 1040, with a college of priests, built by Earl Leofric of Mercia and his wife, Godgifu. This survived until the Norman Conquest, when monks were sent to Wenlock from the abbey of Cluny in France, at the request of Roger of Montgomery whose lands included the abbey site. This meant that Wenlock was now a priory – a house of monks subject to a founding abbey.

Soon after 1100 it was alleged that St Milburge's bones had been found at Wenlock, which brought the priory some fame and made it a place of pilgrimage. Wenlock's first English Prior was appointed in 1376, and in 1395 a charter was obtained declaring the priory English.

Like the other English religious houses, Wenlock ceased to exist during Henry VIII's Dissolution of the Monasteries. In 1540 it was stripped of all its valuables and the buildings were sold. The infirmary and prior's lodge were converted into a private residence and have been used as such ever since.

This guidebook offers a detailed description of the site and a fascinating illustrated history.

❖ CONTENTS ❖

REFERTORY After washing in the lavabo, the monks ate in this building.

LAVABO A particularly elaborate washing-bowl once housed in its own free-standing octagonal building. It has elaborately-carved panels of Wenlock marble, and could be used by 16 monks at once.

DORMITORY RANGE A passageway for the monks' use would have led from here, down night-stairs to the church.

SOUTH TRANSEPT The south 'arm' of the 'cross-shaped' church with three archways that once led into side-chapels. There is a piscina in the west wall and a spiral stair in the end wall facing the nave.

PRIOR'S LODGING A sumptuous house built by Prior Richard at the end of the fifteenth century. It is still occupied today.

Published by English Heritage

23 Savile Row, London W1X 1AB
Copyright © English Heritage 1999
First published by English Heritage 1999

Photographs by English Heritage Photographic Unit
and copyright of English Heritage, unless otherwise stated

Edited by Louise Wilson
Designed by Derek Lee
Printed in England by Westerham Press Ltd
C50, 2/99, FA1972, ISBN 1 85074 735 0

WENLOCK PRIORY

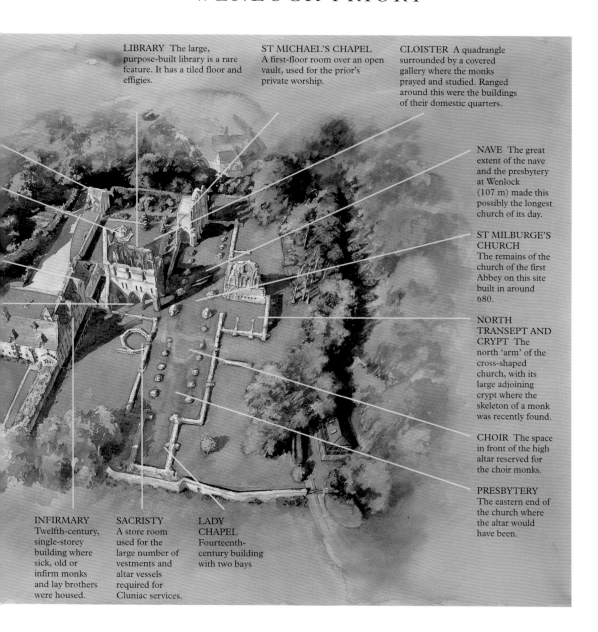

LIBRARY The large, purpose-built library is a rare feature. It has a tiled floor and effigies.

ST MICHAEL'S CHAPEL A first-floor room over an open vault, used for the prior's private worship.

CLOISTER A quadrangle surrounded by a covered gallery where the monks prayed and studied. Ranged around this were the buildings of their domestic quarters.

NAVE The great extent of the nave and the presbytery at Wenlock (107 m) made this possibly the longest church of its day.

ST MILBURGE'S CHURCH The remains of the church of the first Abbey on this site built in around 680.

NORTH TRANSEPT AND CRYPT The north 'arm' of the cross-shaped church, with its large adjoining crypt where the skeleton of a monk was recently found.

CHOIR The space in front of the high altar reserved for the choir monks.

PRESBYTERY The eastern end of the church where the altar would have been.

INFIRMARY Twelfth-century, single-storey building where sick, old or infirm monks and lay brothers were housed.

SACRISTY A store room used for the large number of vestments and altar vessels required for Cluniac services.

LADY CHAPEL Fourteenth-century building with two bays

DESCRIPTION
OF THE PRIORY

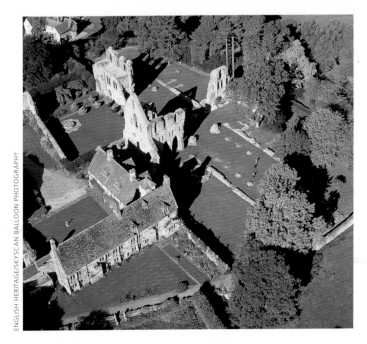

Aerial view of the priory site from the south-east showing the great length of the church

CHURCH

As in all monastic houses, the main building at Wenlock was the church. The ruins show that this was one of the finest monastic churches in the country. The Cluniac order put a lot of emphasis on communal worship and, at over 107 metres (350 feet) long, this was possibly the longest church of its day.

Just after the year 1200, Prior Humbert embarked upon an ambitious project to build a new church at Wenlock Priory. The building took over forty years to complete, with many endowments from Henry III who was a regular visitor to Wenlock.

At the western end of the church was a gable twice as high as the surviving ruins. There were three lancet windows with arcading on each side. The remains of the great west door can still be seen, with its rows of decorated arches.

Looking down the length of the church, you can see the remains of pillars on either side of the central aisle. On the first-floor level, or triforium, there were pairs of arches with a passage behind. The floor above was called the clerestory and

had windows, to throw light down into the church, with a passage in front of them.

ST MICHAEL'S CHAPEL

At the west end of the church, on your right as you walk through its ruined main door, the first three ground-floor arches are partially blocked to support a first-floor room above. This was a chapel, dedicated, like first-floor chapels at other priories, to St Michael, and was for the prior's private worship.

Access to the chapel was from the first floor of the building, which formed the west side of the cloister. This was thought to have been the

cellarium or store room, with the original prior's lodging above.

Please note: there is no public access to St Michael's Chapel.

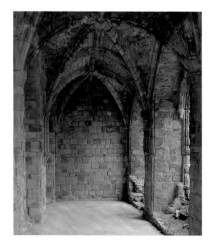

St Michael's Chapel from the south and the topiary in the cloister garden

The blocked aisle arches that support St Michael's Chapel, above

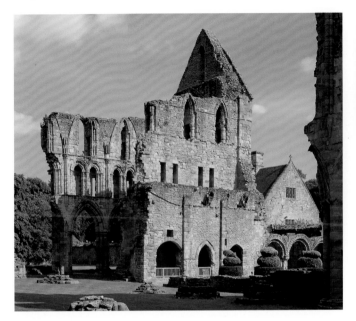

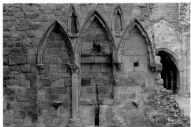

The remains of the laver in the west wall of the south transept

The remains of the south transept and library looking across the nave of the church from the north-west

SOUTH TRANSEPT

The church was built on a traditional cruciform (cross-shaped) plan. If you walk eastwards up the nave of the church you will come to the point where it meets the two 'arms' of the cross (transepts). The transepts contained side chapels, often used for the saying of masses for the dead. This generated a substantial amount of income for religious houses in the Middle Ages.

The south transept is the most impressive part of the remaining ruins at over 21 metres (70 feet) high. It is unusual in that not all the arches for the chapels are the same size. When the eastern parts of the church were

being built in the 1220s, it was intended that the chapter house, to the south, would also be rebuilt. After building the northern two chapels against the crossing, the community changed its mind and decided to retain the existing chapter house. This meant that there was insufficient room to build a third chapel of the same size. The result was that a much narrower archway had to be squeezed into the remaining space.

In the west wall of this transept, the remains of a laver can be seen. This was a rare feature in a monastic church. It was possibly for the

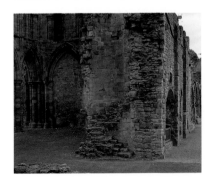

The ruined spiral staircase in the end wall of the south transept

washing of the monks' feet by the prior, to commemorate Christ washing his disciples' feet.

In the end wall (to your left as you leave the south transept), are the remains of a spiral staircase. This would have given access to the triforium, clerestory and gutters.

On the right of the church, beyond the south transept, are the remains of a small, fifteenth-century octagonal building, thought to have been the sacristy, where the altar vessels and vestments were kept. This would have been a much-used building, as elaborate church ceremonies were the focus of Cluniac worship.

NORTH TRANSEPT

Across the nave from the south transept is the north transept. In front of it is a large crypt with a side chapel above it. The function of the crypt is a mystery, particularly as the vaulted undercroft is low and poorly-lit, and not obviously entered from the nave. The main crypt was entered from the transept through a narrow door in the southern bay, which is now blocked but can still be seen. It may have been built to provide additional chapel space for the large community, or to balance the library on the south side of the church.

During a recent excavation, the body of a monk was found just below the surface of the ground in front of the first side chapel of the north

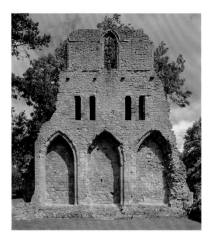

transept. He had been buried holding a simple chalice, which was broken as the ground was disturbed.

THE EASTERN END

Beyond the transepts, the eastern end of the church contained the monks' choir and the high altar, which was placed in front of a screen between the second pair of pillars from the east. A great seven-branched candelabrum over 5.5 metres (18 feet) high, similar to one known to have existed at Cluny, stood near the altar. In the eastern two bays, behind the altar, the shrine of St Milburge itself is thought to have stood, though there is no evidence for it now. In the fourteenth century, a Lady Chapel was added to the east end of the church. It was a building of two bays with a typical late-medieval plinth.

The crypt on the west side of the north transept

The west wall of the north transept of the church

The skeleton of a monk, found buried with a chalice in the crypt of the north transept

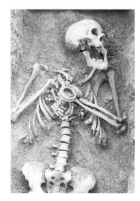

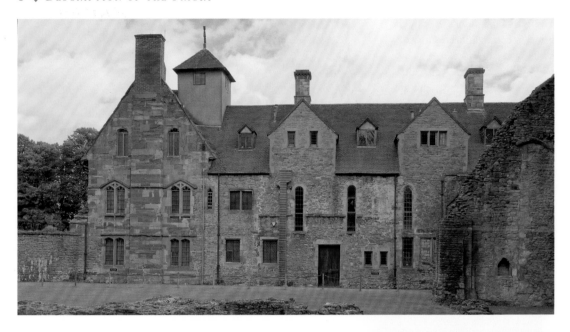

The buildings of the infirmary, built in the twelfth century, on the south side of the site

INFIRMARY

The building on the south side of the church was the infirmary of the priory. Built in the twelfth century, this was originally a single-storey building where sick, old or infirm monks and lay brothers were housed. A second storey was added at a later date, and it formed part of a quad-rangle of buildings, half of which have now completely disappeared. They included the warming room, dormitory and reredorter (toilet block). The main drain, used to carry the priory's waste into a nearby river, would have run under the rere-dorter. The infirmary had its own chapel, kitchen and cloister.

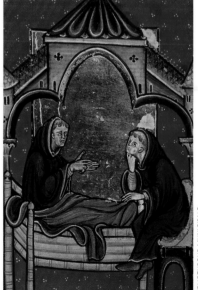

Two monks sit by the bedside of a brother monk who lies sick in the infirmary

In the fifteenth century, Prior Richard Singer built a fine new prior's lodging of Alveley sandstone, which still abuts the infirmary and formed the left side of the quadrangle. There is no record of what buildings were demolished to make way for this fine building. It still retains most of its original features including its roof, which can be seen from the cloister. The opulence of the building reflects the status of the priory and of the prior, as well as the fact that the community had become extremely wealthy.

The infirmary and prior's lodging were converted into a private residence after the priory was closed in 1540, during the Dissolution of the Monasteries, and remain as such to this day.

CLOISTER

The cloister of a medieval monastery formed a quadrangle next to the church. Built around three sides of it were the 'domestic' buildings where the monks ate, slept and studied. The cloister itself was a covered walkway with open, arcaded windows. Monks spent time here in prayer, reading and meditation.

BRITISH LIBRARY

Monks reading

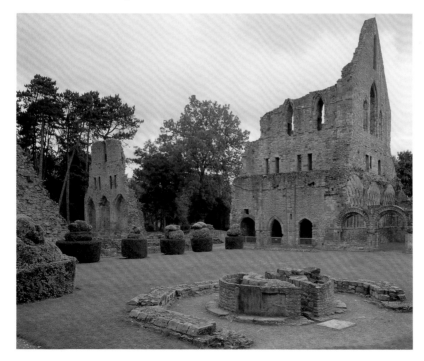

The cloister from the south-west, showing the lavabo, the topiary garden and the library in the south transept wall

Reconstruction of the lavabo in the priory cloister. Built in about 1220, it was where the monks washed their hands before eating

Two stone panels from the Wenlock lavabo. The upper one shows John with his hand on his chin and another unknown apostle. The lower panel shows Christ calling Peter and Andrew on the Sea of Galilee with James and John in another boat

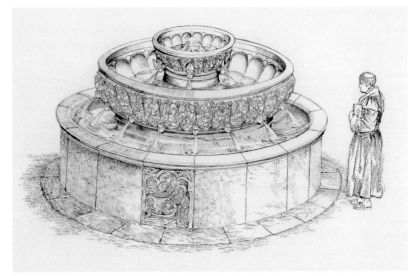

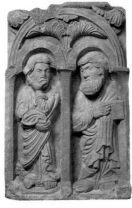

Lavabo

The Wenlock lavabo, a huge water vessel used by the monks to wash their hands before eating, was built in around 1220. Parts of an earlier lavabo of about 1160–80 were reused, notably the carved panels and main basin.

The lavabo was an octagonal building with open arcades which supported a roof. The central structure was of three storeys. Water was fed into a circular cistern and flowed through the mouths of sixteen carved heads into a shallow trough, where sixteen monks could wash simultaneously. The trough had plugholes for drainage, and was supported by a circular base around which were several elaborately carved panels, two of which survive.

The stone used in the lavabo is silurian Wenlock limestone, known as 'Wenlock marble' because it can be highly polished.

The carved pictures on the panels depict Christ and the apostles.

Free-standing lavabos are rare in this country, though common on the Continent. The survival of this form of laver at Wenlock is due to it being a French-influenced, Cluniac priory.

After Wenlock was closed in 1540, although the outer building was destroyed, the base of the inner laver survived as a grassy mound until it was excavated in 1878.

The two panels are replicas of the originals, which have been removed to prevent frost damage.

LIBRARY

On the east side of the cloister is the library. As at most Cluniac monasteries, it backs onto the south transept of the church. Here, however, the usual large book-cupboard was replaced in the early thirteenth century by the purpose-built room that can be seen today.

The two effigies that can be seen are from the tombs of former priors and were moved to their present position from another part of the monastery. On the floor are fragments of locally-made medieval tiles which have been re-laid to give an impression of the original appearance of the floor of the church.

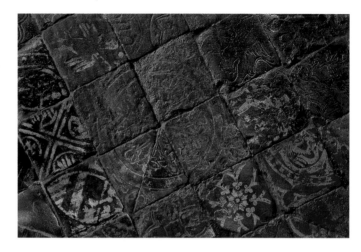

The library originally had one central doorway. The other two entrances were introduced after the Dissolution of the Monasteries, when the priory was used as a farm.

Part of the tiled floor in the library

The arches of the library on the east side of the cloister

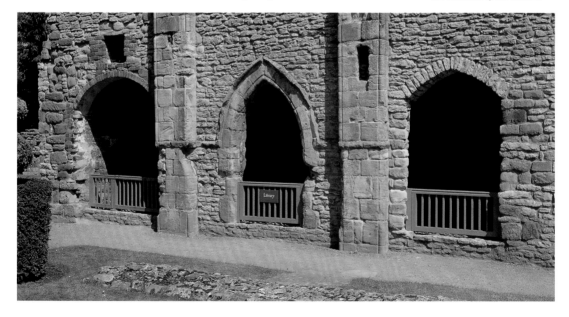

The arches leading from the cloister into the chapter house

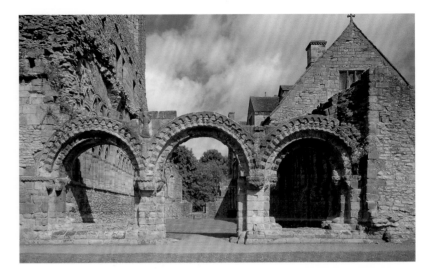

CHAPTER HOUSE

The Norman chapter house was built in around 1140 and was so-called because a chapter from the rule of St Benedict was ritually read at the daily meeting here. This was the 'business' centre of the monastery, where the monks and the prior met each morning to discuss priory affairs and issue punishments for disobedience.

The elaborate false arcading on the south wall of the chapter house

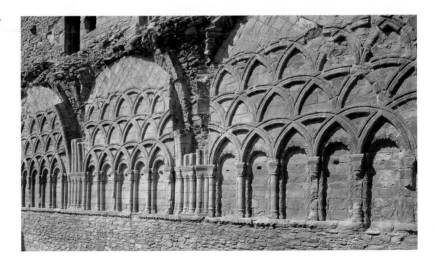

The chapter house followed the traditional design of a central doorway from the cloister with a window on each side of it. The eastern end originally had an apse, but this was removed when a square east wall was built in the fourteenth century.

Much of the elaborate arcading and detailed stone carving typical of Cluniac buildings can still be seen on its interior walls. Lining the walls were stone benches where the monks sat. Towards the back on the right, a blocked doorway can be seen, which once led to a treasury under the day stairs. The lintel has an unusual carving of a grotesque head – an example of Anglo-Scandinavian sculpture.

The openings in the back wall date from after the monastery was closed down, when the chapter house was used as a dairy.

A reconstruction drawing by Peter Urmston, of the chapter house as it would have been in the fourteenth century

A grotesque head, humorously carved into the lintel of the doorway in the south wall of the chapter house

❖ THE CLUNIAC ORDER ❖

The Cluniac Order was founded in AD 910. Until this time, monks followed the Benedictine Order, based on the Rule of St Benedict, but all the monasteries were independent of each other. This began to change in the tenth and eleventh centuries when reformers began to form new orders, each of which had its own particular routines and customs. The Abbey of Cluny was the first to found other monasteries, which it saw as extensions of the founding house. All Cluniac monks had to swear obedience to the Abbot of Cluny.

The Cluniac Order was distinguished by its emphasis on highly elaborate church ceremonial and the Cluniacs were respected in the tenth and eleventh centuries for

Monks at mass. The Cluniacs put great emphasis on elaborate church services

BRITISH LIBRARY

their dedication to formal worship. The architecture of the Cluniac churches was often correespondingly elaborate.

So much of the Cluniac day was devoted to church services that the monks had no time for manual labour, but much of the priory's wealth was devoted to helping the poor and needy. Later

orders, such as the Cistercians, thought this was too extreme, and included lay brothers who spent less time in church and more on crafts or agricultural work.

THE DAY OF A CLUNIAC MONK

The Cluniac timetable is thought to have looked something like this:

2am	**Matins** in church. Lauds in church.
3am	Return to bed.
6am	**Prime** in church. Light breakfast followed by work.
9am	**Terce** in church. Mass in church.
10am	Meeting in chapter house. Study and reading.
12pm	**Sext** in church. Mass in church.
2pm	Dinner – the main meal.
3pm	**None** in church. Siesta.
5pm	**Vespers** in church.
6pm	Light supper.
7pm	**Compline** in church. Bed.

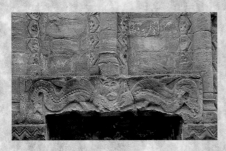

The highly-decorated lintel over a doorway in the chapter house

HISTORY OF THE PRIORY

MILBURGE

King Merewalh of Mercia, the youngest son of the pagan king Penda, acquired land in Shropshire and founded an abbey shortly after 680. The place, later to be called Much Wenlock, was then known as Wimnicas or Wininicas. Merewalh sent his eldest daughter, Milburge to be educated at Chelles, near Paris, while the newly founded abbey was presided over by the abbess Liobsynde.

Milburge came to Wenlock in 687 and succeeded Liobsynde as abbess. The monastery was then a double house of monks and nuns (common practice at that time), with two sets of church buildings so that they could worship separately. It is thought that the monks' main church was sited at the crossing of the present priory church, and the nuns' main church on the site of today's parish church. The other churches have not yet been looked for or excavated.

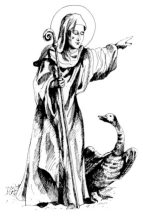

St Milburge, who, among other miracles, was said to have made the geese that were eating her crops disappear for ever

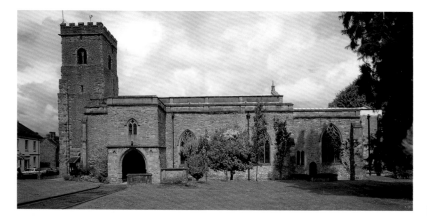

The Parish Church of Holy Trinity. This may have been the site of the nun's church of the original seventh-century priory

An abbot reading a book, from an illuminated manuscript

Milburge ruled over the community for 30 years, and stories of miracles accumulated around her. She was said to have brought a dead boy back to life, banished geese that were ravaging her fields, and caused her veil to float on a sunbeam.

Milburge's royal connections undoubtedly helped in her monastery's acquisition of land and property. Towards the end of her life, she dictated the 'Testament of Milburge', a copy of which survives. In this she lists all the monastery's territorial possessions 'lest my death incur discredit through ignorance of the church's property'. Milburge lived into her sixties at a time when the average life expectancy was about forty. She died sometime between 722 and 730, and after her death was recognised as a saint.

After this, the history of Wenlock becomes hazy for a time. In the ninth century, Mercia was often subjected to raids by the Danes, who swarmed all over the Midlands until they were stopped by King Alfred. Many religious houses were a target because of their supposed wealth, and it is thought that Wenlock was attacked in around 874. However, the monastery must have survived in some form, because the names of two Wenlock nuns appear as witnesses on a charter at Shrewsbury in 901. Double monasteries went out of fashion and, shortly before the Norman Conquest, Earl Leofric, of

Mercia, and his wife Lady Godiva, founded and lavishly endowed a minster at Much Wenlock. This was a college for secular canons which served the spiritual needs of the surrounding area.

In 1066, William of Normandy successfully invaded England, and rewarded his loyal supporter, Roger de Montgomery, with vast estates in Sussex and Shropshire. Roger made a request to the Abbot of Cluny in France for monks to come to Wenlock, and a number of monks from La Charité sur Loire, a daughter-house of Cluny, were sent to Wenlock in around 1080. Cluny liked to retain control of its foundations, so the former abbey at Much

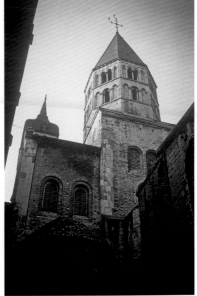

The tower of the Abbey of Cluny from which Wenlock Priory was founded in about 1080

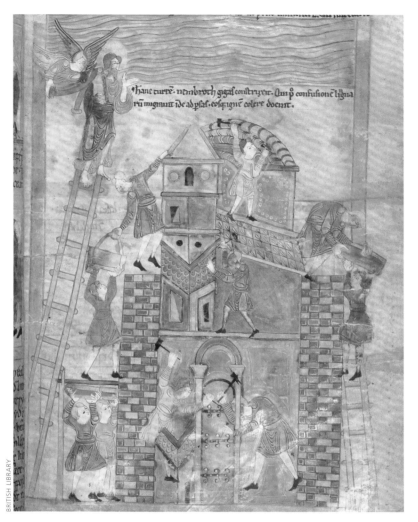

BRITISH LIBRARY

An eleventh-century depiction of the Tower of Babel, giving an idea of how building work was carried out at this time

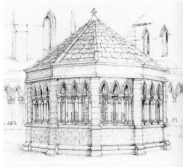

The lavabo house

Wenlock became a Cluniac priory dedicated to St Milburge and St Michael, and paid an annual rent or *apport* to Cluny. The French monks utilised the recently built church and set to work erecting new domestic buildings. The chapter house, lavabo and infirmary are all that remain of this early work.

In 1101, according to a manuscript now in Lincoln Cathedral, an old box was found during building work at the

A sixteenth-century illustration of Chaucer's pilgrims visiting Canterbury. Wenlock became a popular place of pilgrimage in the twelfth century

BRITISH LIBRARY

parish church. It contained an ancient document written in 'the English language' which told of the burial of St Milburge near the altar. The church was in a ruinous state and although the monks searched the ground, nothing was found. It was said that a short time later, two boys were playing in the church when a pit opened up to reveal the 'beautiful and luminous bones' of St Milburge. These were placed in a

❖ THE EARLY CHURCHES ❖

The priory church is not the first building to occupy this site. During recent excavations evidence has been found of a Roman building that was probably roofed and standing to its full height into the early twelfth century. The Roman building was probably incorporated into the fabric of St Milburge's abbey, built in about AD 680.

At the time, it was fairly common for religious sites to incorporate surviving Roman buildings, which the Saxons believed to be associated with the Christian past of the country. The remains of this church lie below the present ground level in the centre of today's ruins.

Milburge's church was a rectangular building 10.6m (35ft) long and 8.5m (28ft) wide with an eastern apse or rounded end. The footings of a free-standing tower were uncovered during excavations.

Leofric's church

Milburge's church

The next building on the site was a fine minster, built and lavishly endowed by Leofric, Earl of Mercia (husband of Lady Godiva). The remains of this church, built in around 1140, occupy the same site as Milburge's church, although it was much larger, at over 30m (100ft) long by 21m (70ft) wide, with a central eastern apse and two side aisles.

shrine and stories of miraculous cures became connected with them. A woman with a mysterious wasting disease drank some of the water used to wash the bones. It was said that she vomited a great worm and was cured. In another story, a blind woman was said to have had her sight restored after an all-night vigil at the shrine. Lepers were said to be cured and a drowned boy revived. Monks who fell from the scaffolding during the building of the new church were allegedly uninjured because of the divine intervention of the 'blessed virgin'.

Pilgrims began to come to Wenlock in increasing numbers, and a town began to grow outside the walls of the priory. The success of the shrine can be judged by the fact that the monks of Shrewsbury Abbey went to great pains to bring back the bones of St Winifred from Wales to use as a counter-attraction.

Wenlock Priory soon became strong enough to establish a daughter-house, St Helen's Priory, on the Isle of Wight, as well as other foundations at Dudley, Paisley in Scotland and nearby Church Preen.

A COLOURFUL HISTORY

Just after 1200, Prior Humbert obtained various grants which enabled the building of a large new church to begin. Humbert was friendly with the king, Henry III, who stayed at the priory on a number of occasions. Many royal edicts were issued from Wenlock and the king imported his own wines to be stored at the priory for royal use. Henry gave gifts of timber from the royal forests, including 15 oaks 'for the horologium' (probably a large, decorative clock case).

Wenlock had its share of infamy over the centuries. In 1272 John de Tycford was appointed as prior. He had previously been prior of Bermondsey and had brought that monastery to ruin by his dealings with a notorious money-lender, Adam de Stratton. John de Tycford's activities at Wenlock brought the priory into debt, and, as a final act before being deposed, he sold the wool crop of the monastery for seven years in advance and kept the money. He was unpopular with the monks and one of them, William of Broseley, left the priory at this time and gathered together an armed band of men who hid in the forest, threatening to kill the prior. A government order of 1276 instructed sheriffs 'to arrest vagabond monks of the Cluniac order'. John de Tycford was eventually captured and, according to the Worcester chronicler 'received what he deserved'.

In 1417, the outlaw Sir John Oldcastle met a criminal, William Careswell, who specialised in counterfeiting coins and brought him to Wenlock Priory where he instructed some monks in the art. Sir John

A penny from the reign of Henry III

The cellarer who looked after the wine in medieval monasteries

Drawing of the priory as it would have looked in around 1500

An original twelfth-century charter from Wenlock, by which Prior Humbert sanctioned the transfer of some of the Priory's land to Thomas Bagerhovere

devised a plot to kill the king, Henry V, by black magic, using a wax image three feet long, slowly roasting over a fire. Careswell was arrested after leaving Wenlock and at his trial he incriminated the prior, John Mar, in the plot. Prior Mar was eventually acquitted due to lack of evidence.

During the Hundred Years War with France (1337–1453), French monasteries in England, known as 'alien', were subjected to severe taxation and loss of land holdings. Wenlock managed to hold on to most of its possessions on condition that £170 was paid annually to the Crown. When this amount became an impossible burden, Wenlock applied for a charter of denization to declare the priory English. The charter was obtained in 1395 from King Richard II for the payment of £400 and an undertaking that prayers were said annually on the anniversary of the death of his queen, Anne of Bohemia. The charter freed Wenlock from its burden of fines and taxes, and the 100 shillings that had been paid annually as *apport* to La Charite, was given instead to Kings College, Cambridge.

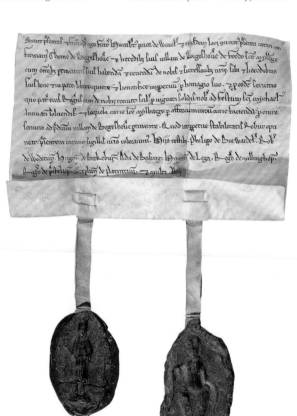

THE DECLINE OF THE PRIORY

In 1521 there was a dispute over the election of the prior which resulted in a visitation by Dr John Allen, who

published his report after taking evidence from every monk at Wenlock. His 'Injunctions and Exhortations' show how the once-strict following of the rule of St Benedict had by this time become slack, although Wenlock was not alone in this respect. The list of 'Injunctions and Exhortations' included the following:

- The rule of continuous silence must be kept more strictly.
- There must be no dealings with women. They are forbidden the cloister absolutely.
- Monks must conform to the rules about regular attendance in church, sleeping in the dormitory and eating in the refectory.
- Private property is forbidden.
- Monks must not hunt and their dogs must be expelled from the cloister, dormitory and indeed from the monastery.
- Gambling on games of cards, marbles and chess is forbidden.
- Monks must not take boys to the dormitory or have them in their company.

- Monks must not carry arms, nor must they form cliques and conspiracies.
- After compline, monks must go to the dormitory and not walk in the garden or go outside the monastery; they must not indulge in late drinking.
- After bleeding, monks may rest for two hours a day; they must not go to a grange for convalescence.
- Monks must be content with food and clothes instead of salaries, but they may receive payment for funerals.
- The prior should not indulge in luxurious and extravagant living with a large household.
- Everyone, from the prior downwards, is forbidden to ask anyone what he said at this Visitation.

So, according to Dr Allen, immorality, easy living and lack of worship had, by 1521, brought Wenlock Priory into disrepute.

The Rule of St Benedict which was supposed to govern the behaviour of all monks and nuns

BRITISH LIBRARY

A monk and a nun in the stocks, being punished for immoral behaviour

BRITISH LIBRARY/BRIDGEMAN ART LIBRARY

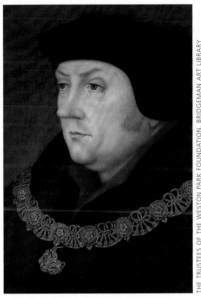

Thomas Cromwell, who organised the closure of the monasteries for Henry VIII

The Dissolution of the Monasteries

The last prior at Wenlock was John Bayley. His period in office was overshadowed by the growing crisis of King Henry VIII and his request for a divorce so that he could marry Anne Boleyn. Henry eventually declared himself head of the church in England. Thomas Cromwell replaced Cardinal Wolsey and began to assess the wealth of the monasteries. After the Act of Suppression in 1536, those monasteries with an annual income of less than £200 were forcibly closed. There was a brief rebellion against the closure of the monasteries – the 'Pilgrimage of Grace' – which was savagely suppressed with over 30 monks executed. From then on it was only a question of time. Wenlock, being a wealthy house, was spared until 24 January, 1540, when, in the presence of three of the king's commissioners, the monks and prior signed their names on the deed of surrender.

The prior and many senior monks received pensions, and monastic life, which had existed at Wenlock for over 800 years, came to an end.

Work began immediately to strip the priory of all its valuables. Gold and silver vessels and jewellery were taken to the Jewel House in the Tower of London. The estate was eventually given to the King's physician, Augustin de Augustini, a Venetian, who immediately broke up the estate and sold it. The monastic site and the Wenlock land were sold to Thomas and Richard Lawley, who converted the infirmary and prior's lodging into a dwelling house.

The rest of the monastic buildings were slowly and systematically demolished and the stone used to build houses, walls and farm buildings for miles around. Nature encroached on what was left, festooning the ruins with plants and bushes. Wenlock Priory became a farmyard and cows were milked in the south transept of the church.

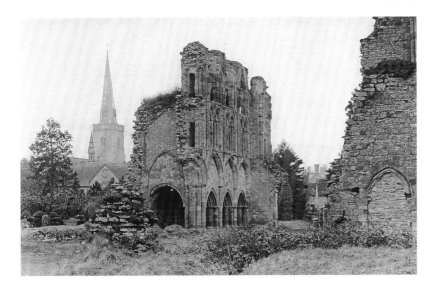

The ruins of Wenlock Priory looking overgrown in the nineteenth century

LATER HISTORY

In the eighteenth and nineteenth centuries, monastic ruins came to be appreciated for their romantic beauty. They were popular as settings for picnics, and artists were inspired to paint them.

At Wenlock, the ruins became a feature of a nineteenth-century garden, parts of which can still be seen in the cloister, associated with the mansion in the old prior's house.

Scholarship followed fashion, and in the second half of the nineteenth century, historians turned their attention to sites like Wenlock. In 1901, the Vicar of Much Wenlock,

Three nineteenth-century postcards of Wenlock Priory

Dr Cranage (later Dean of Norwich), carried out an important excavation in the church, which identified the remains of what he considered to be parts of St Milburge's church and that built by Earl Leofric, establishing the importance of the site and demonstrating its potential for future research. More recently, Humphrey Woods has re-examined the evidence for the early churches at Wenlock and identified the late Roman origins of the site.

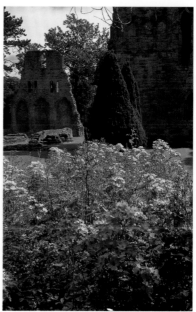

The ruins of Wenlock Priory were eventually given into the care of the Ministry of Works and then to English Heritage, and much work

Part of the garden, created in the nineteenth century to enhance the priory ruins, still remains in the cloister

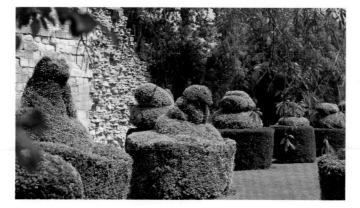

was done to consolidate the remaining ruins, including the removal of debris and the restoration of the thirteenth-century ground level.

Today, imagination must suffice to restore the original grandeur of Wenlock Priory and envisage the lives of the monks who dedicated their lives to God.